Dot-to-Dot

FAMOUS FACES

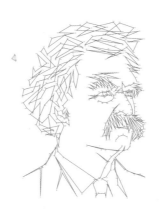

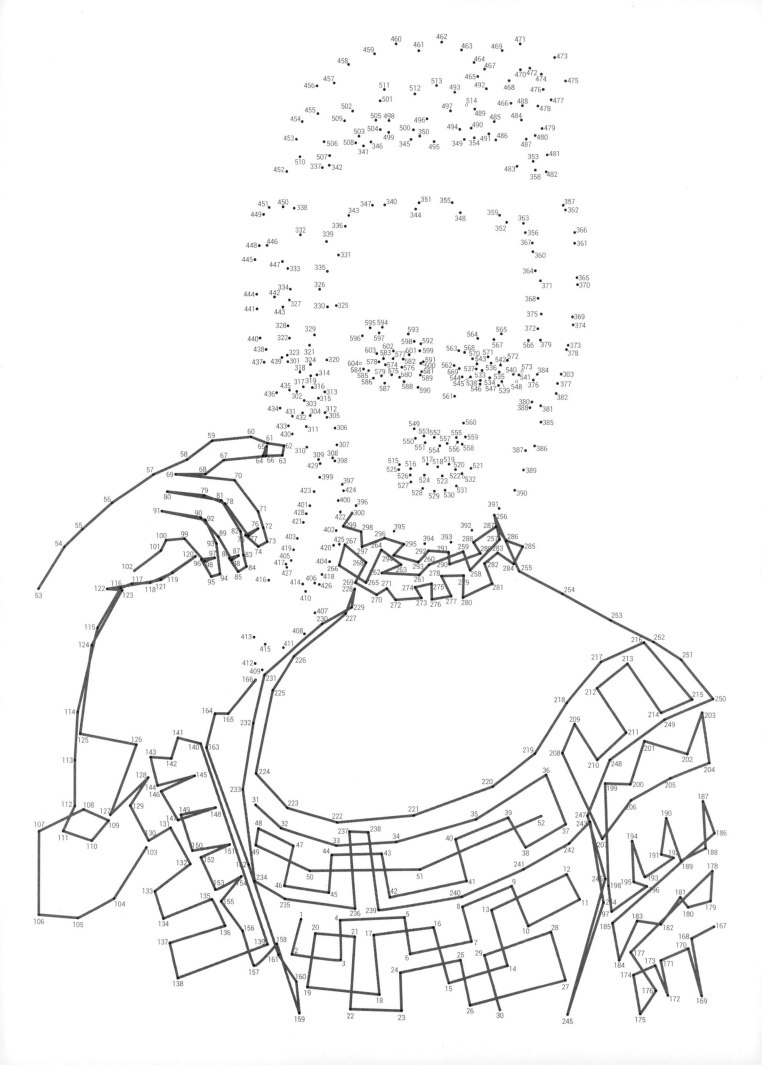

Dot-to-Dot
FAMOUS FACES

Join the dots to reveal the great history-makers

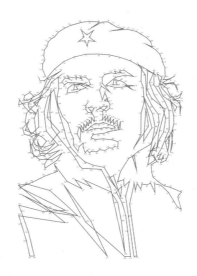

Glyn Bridgewater

southwater

Introduction

Dot-to-dot puzzles have long been a popular activity for young and old alike, with the opportunity to happily while away the hours uncovering hidden characters, animals, buildings and places. This fabulous new book takes simple join-the-dot art to the next level with 40 puzzles of famous historical figures to complete. Intricate, challenging and rewarding to finish, the puzzles range from 313 to 943 dots and will have you transfixed as you progress from dot to dot trying to see what image materializes.

An absorbing and relaxing activity that can calm and reduce daily stresses and anxieties, these brain-stimulating puzzles can contribute to alertness. There are also proven educational benefits to doing dot-to-dot activities. It helps to build fine motor skills, improve concentration levels and strengthen mapping skills – all while creating memorable art to enjoy. Each drawing may take approximately half an hour to complete, perfect for a rainy day or holiday activity, or simply a chance to take yourself away for some peace and quiet for a while.

The famous faces included here are all key figures from history. There are political leaders, Hollywood actors, kings and queens, sports personalities, musicians and many more. They have all rightly earned their position as history-makers and all have been photographed or

painted many times. These iconic faces have been captured as dot-to-dot puzzles, their personalities waiting patiently to emerge from the depth of the dots to reveal who they are.

As some of the drawings are quite intricate in parts it is best to use a pen (rather than a pencil) with a fine tip. Starting at number 1, connect the dots in numerical order. If a number is next to a circle rather than a dot, lift your pen and start again at the next consecutive number. This number may not necessarily be close to the previous number, it can be anywhere on the design.

Continue completing the picture in this manner, picking up your pen whenever you come to a circle until you have come to the last dot. For the most accurate picture, try to keep a relatively straight line between the connecting dots, but don't worry if you make a mistake or have a wobbly line, it won't affect the finished piece.

Once you have completed your dot-to-dot artwork, turn to the back of the book where you can compare your work with the finished solution and also read some interesting facts about the life of the history-maker you have drawn.

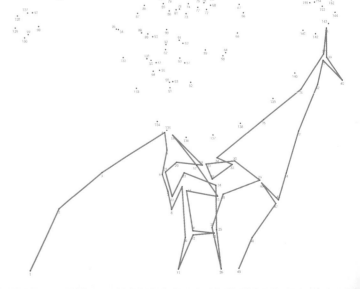

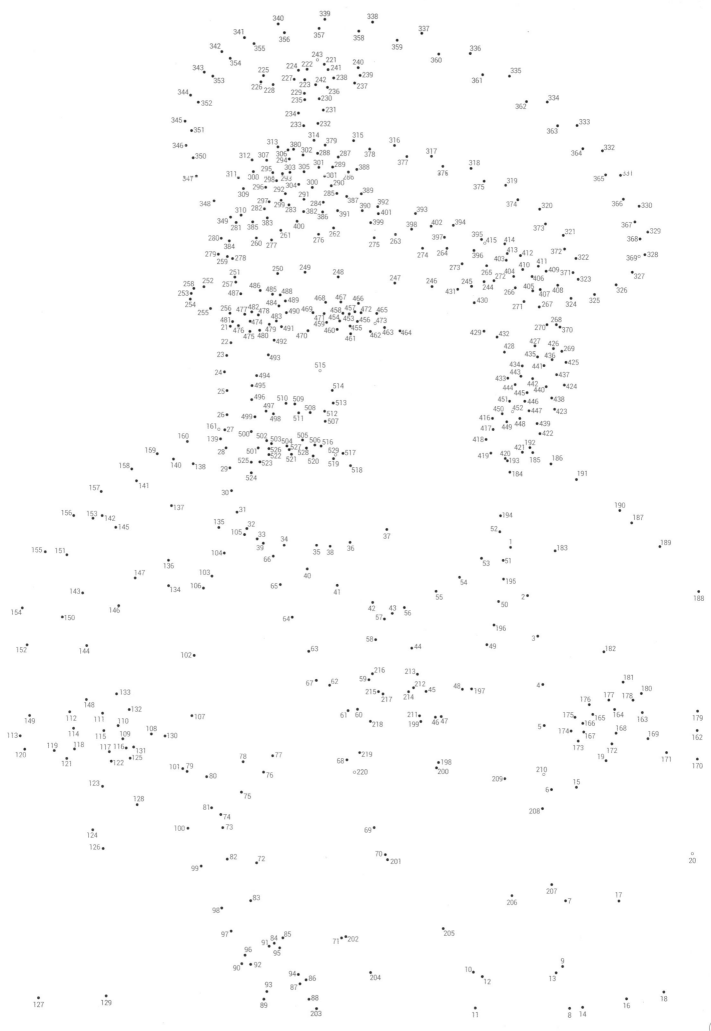

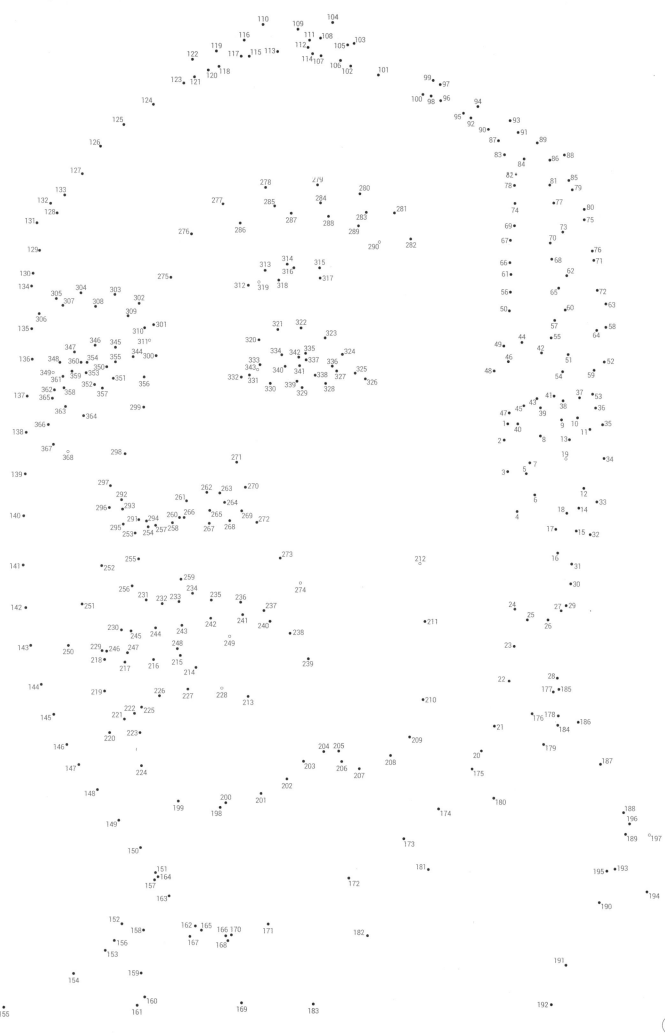

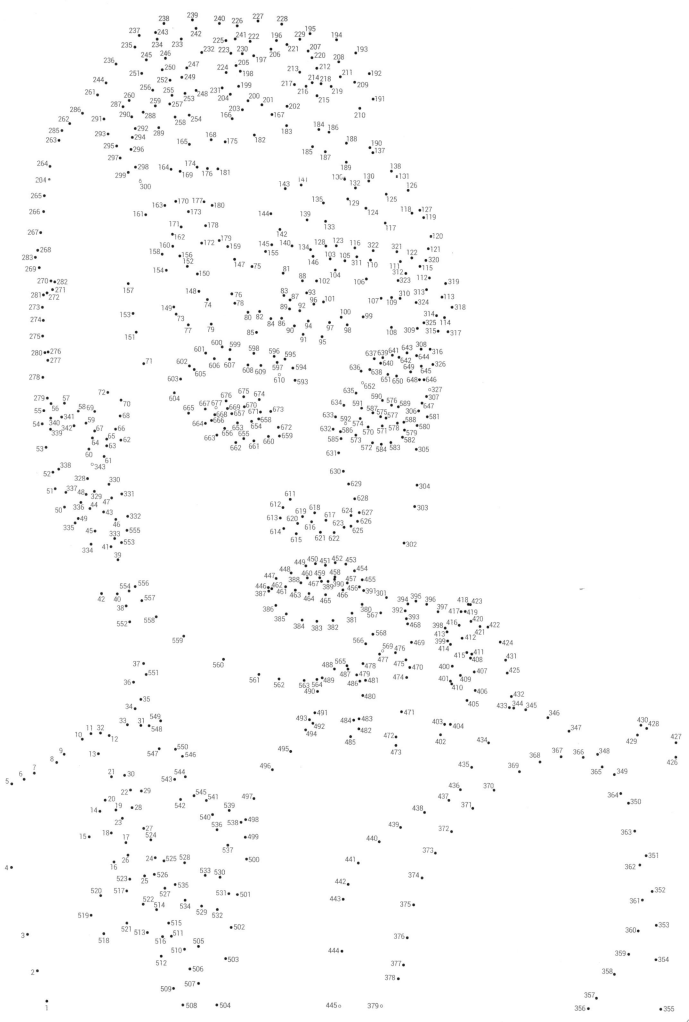

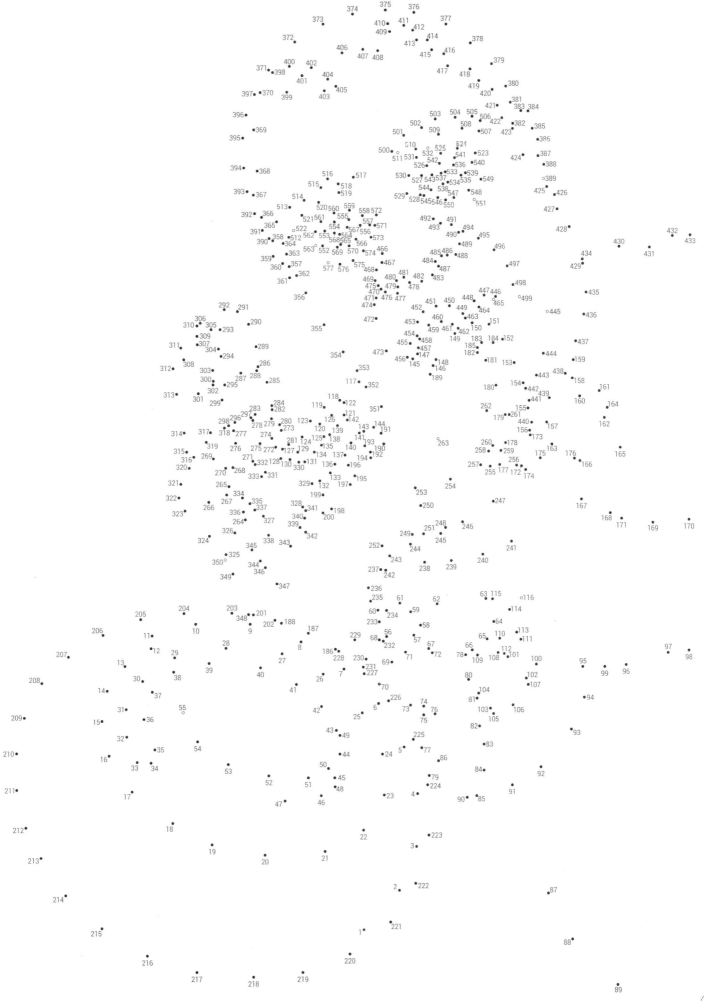

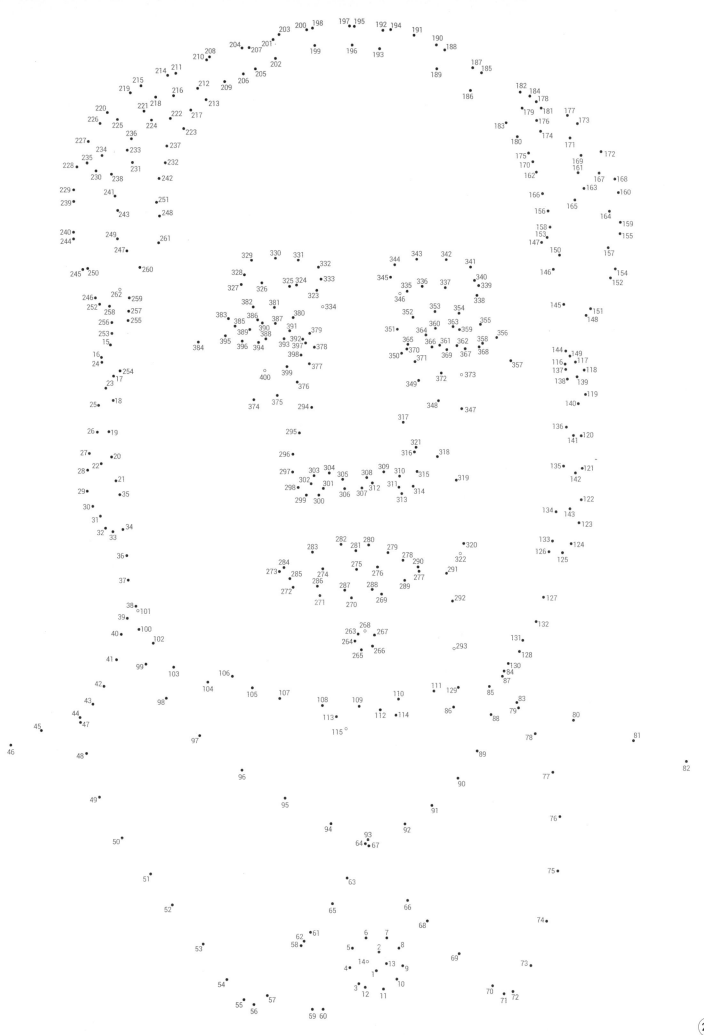

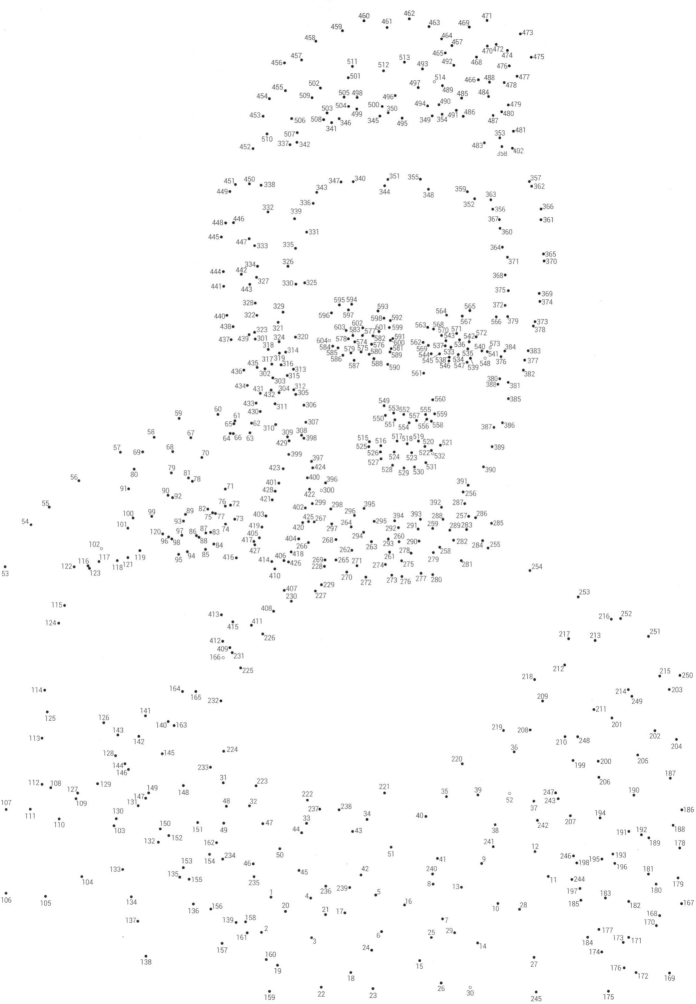

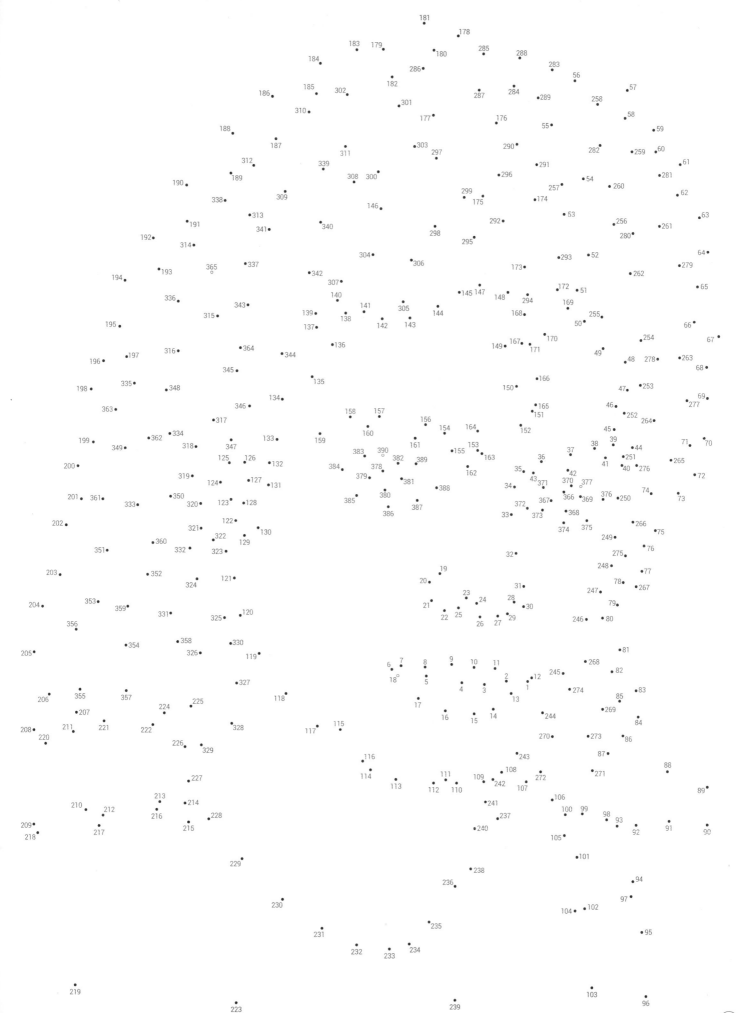

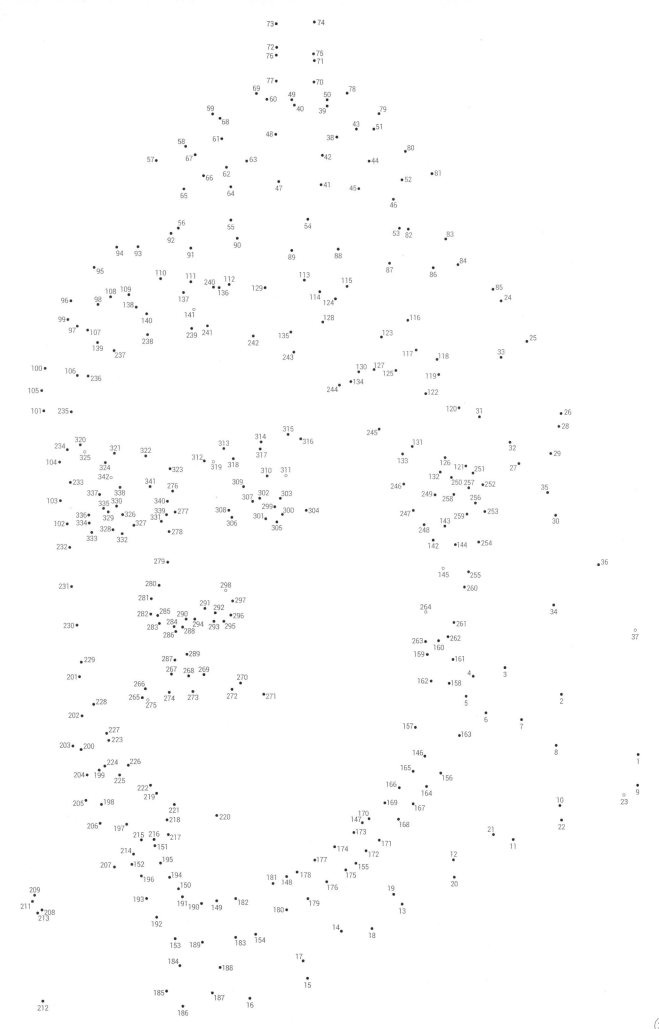

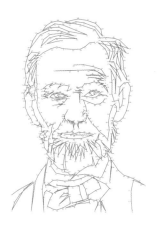

Page 1

Abraham Lincoln, 1809—1865

Lincoln was the 16th American President, and is considered by many to be the greatest ever. Lincoln faced the prospect of governing a separated country when the American Civil War broke out just after his inauguration in 1861, but his strong belief in liberalism ensured the Union remained together and slavery was eventually abolished. Days after the war finished he was assassinated while watching a play. **563 dots**

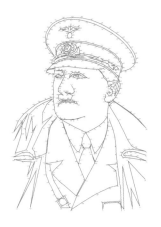

Page 2

Adolf Hitler, 1889—1945

Hitler was the man largely responsible for WWII, the deadliest conflict in human history. As a veteran of WWI, Hitler turned to politics before leading the Nazi Party to German government in 1933. He was behind the deaths of at least 11 million Jews and other minorities in the Holocaust; an attempt to create a 'pure' race. Hitler took his own life once it was apparent the war was lost. **529 dots**

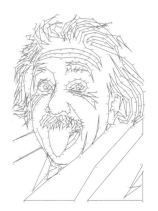

Page 3

Albert Einstein, 1879—1955

Best known for his formula $E = mc^2$, Einstein was the father of modern physics. Building on the work of Isaac Newton, he developed the general theory of relativity and won the Nobel Prize in 1921 for his services to theoretical physics. Despite his strong opposition to the use of nuclear weapons, this theory formed the basis of the atomic bombs dropped on Hiroshima and Nagasaki, which effectively ended WWII. **552 dots**

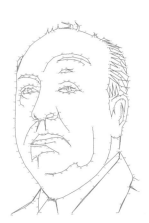

Page 4

Alfred Hitchcock, 1899—1980

Nicknamed 'The Master of Suspense,' Hitchcock was one of the most influential filmmakers of all time. He enjoyed success in both silent films and early Hollywood 'talkies', thanks to thrilling plots, twist endings and sexual undertones. His most famous film, 'Psycho' (1960), features a memorably violent shower scene. Hitchcock was no stranger to controversy and is alleged to have said "actors are cattle." **368 dots**

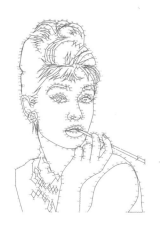

Page 5

Audrey Hepburn, 1929–1993

Born Audrey Kathleen Ruston, Audrey Hepburn was a British actress and humanitarian who was one of the greatest female screen legends of the Golden Age of Hollywood. Following several minor film appearances, she shot to stardom playing the lead role in 'Roman Holiday' (1953). Among her many successful films were 'Breakfast at Tiffany's' (1961), and 'My Fair Lady' (1964). During her later years she devoted her life to UNICEF in impoverished areas of Africa, South America and Asia. **677 dots**

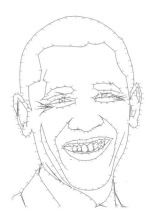

Page 6

Barack Obama, 1961–

Barack Hussein Obama II is the 44th President of the United States and also the first African American to hold the office. He defeated Hilary Clinton in the Democratic Party primary campaign and John McCain in the general election. Obama was re-elected in 2012, and his policies have included passing health care reform and withdrawing US troops from Iraq. **390 dots**

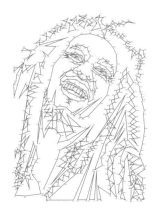

Page 7

Bob Marley, 1945–1981

Considered the greatest reggae singer of all time, Robert Nesta 'Bob' Marley began his career with the group The Wailers and after they had disbanded pursued a successful solo career, selling over 70 million records worldwide. Hailing from Jamaica, he became an international star in the 1970s with songs such as 'I Shot the Sheriff', 'No Woman No Cry', and 'One Love'. A committed rastafari, he died of cancer aged 36. **741 dots**

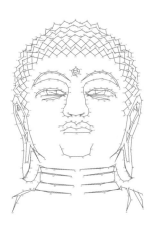

Page 8

Buddha, 6th-4th century BCE

According to Buddhist tradition, Siddhārtha Gautama was born in Lumbini (now Nepal), and spent the first 29 years of his life sheltered from the outside world in an opulent palace built by his father. When he left the palace and encountered suffering among the Nepalese people, he lived an austere life for five years before finding enlightenment and becoming the Buddha (the 'awakened one'). He practised his teachings for 80 years. **489 dots**

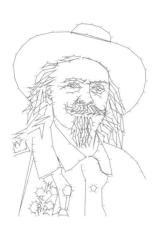

Page 9

Buffalo Bill, 1846–1917

William Frederick Cody was a scout, bison hunter and showman. He earned his nickname for reputedly hunting and killing over 4,000 buffalo to supply Kansas Pacific railroad workers with food. He rode for the mail service The Pony Press aged 14, and fought in the American Civil War for the Union. He founded the hugely popular circus-style show Buffalo Bill's Wild West in 1883, which toured for the next three decades. **474 dots**

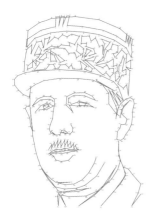

Page 10

Charles de Gaulle, 1890–1970

Charles André Joseph Marie de Gaulle served as 18th President of France from 1959-1969. He had served as a soldier in WWI and as a commander in WWII, before being elected president after a successful political career. He protected France from the influence of the USA and the Soviet Union, and helped Algeria achieve independence. He is seen as one of France's greatest heroes. **412 dots**

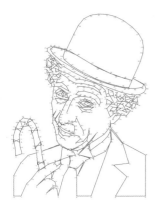

Page 11

Charlie Chaplin, 1889–1977

Sir Charles Spencer 'Charlie' Chaplin's recurring character The Tramp made the Englishman a sensation in Hollywood's silent film era. Chaplin directed and starred in bumbling, slapstick comedies such as 'The Kid' (1921), 'The Circus' (1928), and 'The Gold Rush' (1925), but refused to embrace sound films in the 1930s. He caused controversy in the 1940s for a string of affairs and marriages to much younger women. **434 dots**

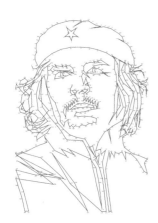

Page 12

Che Guevara, 1928–1967

Now as famous for the iconic photograph of him taken by Alberto Korda as for his politics, Ernesto 'Che' Guevara was a major figure in the Cuban Revolution. He was born to an Argentine middle-class family, but as he grew up he became aware of widespread poverty in South America and joined Fidel Castro in the fight to overthrow the Cuban dictator Fulgencio Batista. He was executed by the Bolivian army after leading a rebellion there. **489 dots**

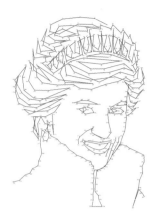

Page 13

Diana, Princess of Wales, 1961–1997

Diana Frances Spencer became Princess of Wales in 1981 when she married Prince Charles. She was immensely popular for her charm and looks, as well as her charity work, most notably with AIDS patients, and her campaign against landmines. Diana is the mother to Princes William and Harry, but she and Charles divorced in 1996. The world was stunned to hear the news of her death in a car crash in Paris. **402 dots**

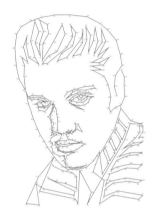

Page 14

Elvis Presley, 1935–1977

Elvis Aaron Presley came from humble origins in Memphis to become the unofficial 'King of Rock and Roll'. He had 18 number-one singles, including 'Jailhouse Rock', 'Hound Dog', and 'Suspicious Minds', and also forged a successful acting career. Presley fought a long battle with prescription drugs and died of heart failure aged 42. He remains today one of the world's most popular music icons. **354 dots**

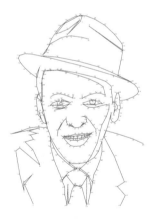

Page 15

Frank Sinatra, 1915–1998

Francis Albert 'Frank' Sinatra is one of the most popular American jazz and traditional pop singers, actors and producers of the 20th century. As a swing singer his biggest hits include 'Come Fly with Me', 'My Way', and 'New York, New York', while on screen he won a supporting Academy Award for his role in 'From Here to Eternity' (1953). Sinatra also made headlines for his turbulent relationships with Ava Gardner and Mia Farrow. **339 dots**

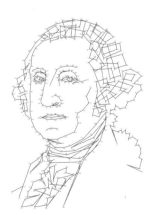

Page 16

George Washington, 1732–1799

Washington became the first President of the United States after being the Commander-in-Chief of the Continental Army during the American Revolutionary War. He has been called the 'father of his country' after presiding over the convention that drafted the United States Constitution. He is considered one of the top three American presidents of all time for his role as a founding father, his belief in liberty, and principles of Republicanism. **410 dots**

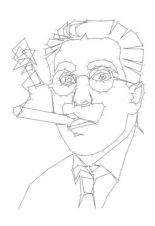

Page 17

Groucho Marx, 1890–1977

Julius Henry 'Groucho' Marx entertained people with his sharp wit and one-liners for nearly 70 years. He was the third born of the five Marx brothers, who performed together as a family comedy act for over 40 years and appeared in 13 films including 'Duck Soup' (1927) and 'A Night at the Opera' (1935). Groucho was famous for his thick glasses, huge moustache and fat cigar. He remained popular hosting the game show 'You Bet Your Life' on radio and television. **323 dots**

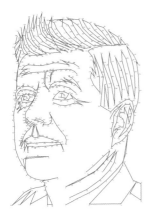

Page 18

John F. Kennedy, 1917–1963

John Fitzgerald 'Jack' Kennedy's short term of office as the 35th President of the United States included some tumultuous events. With tensions with the Soviet Union at their highest, Kennedy presided over the Bay of Pigs Invasion, the Cuban Missile Crisis, developments in the Space Race and the building of the Berlin Wall. He was assassinated by Lee Harvey Oswald, an event which still attracts conspiracy theories. **531 dots**

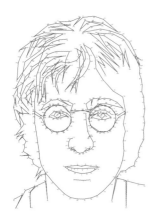

Page 19

John Lennon, 1940–1980

John Winston Lennon was co-founder of the Beatles, arguably the most successful band of all time. His songwriting partnership with Paul McCartney helped produce a roster of hits in the 1960s, with 'Beatlemania' at its peak. He left the group in 1969 to release solo material and collaborations with his wife Yoko Ono including the iconic songs 'Give Peace a Chance' and 'Imagine'. Lennon was murdered outside his Dakota apartment by Mark David Chapman. **457 dots**

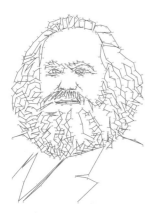

Page 20

Karl Marx, 1818–1883

Marx's two most famous works 'The Communist Manifesto' (1848), co-authored with Friedrich Engels, and 'Das Kapital' (1867–1894) had a profound impact on the 19th and 20th centuries. He believed that societies progress through class struggle, and that capitalism would eventually be replaced by socialism. He is now considered one of the most influential writers, economists and philosophers in human history. **558 dots**

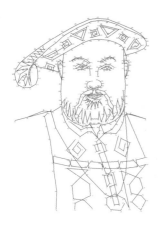

Page 21

King Henry VIII, 1491–1547

Aside from his six marriages, Henry VIII is known for his role in separating the Church of England from the Roman Catholic Church. He divided opinion between those who saw him as a modern Renaissance man, and those who saw him as a vulgar hedonist. Inheriting the throne from his father Henry VII, he was determined to produce a male heir, and beheaded two of his wives for adultery and treason. **509 dots**

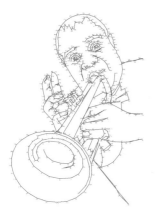

Page 22

Louis Armstrong, 1901–1971

Nicknamed 'Satchmo' or 'Pops', Armstrong hailed from New Orleans and rose to prominence as a jazz trumpeter and singer in the 1920s. He was one of the most influential jazz artists of all time, and one of the first African-American entertainers to 'cross over', where his skin colour was secondary to his music. His career spanned four decades and included the songs 'Star Dust', 'La Vie En Rose', and 'What a Wonderful World'. **577 dots**

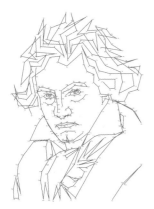

Page 23

Ludwig van Beethoven, 1770–1827

One of the most renowned Classical composers of all time, Beethoven's legacy is all the more impressive considering he was fully deaf in his later and most productive years. Born in Germany, Beethoven was the most influential figure in the musical transition between the Classical and Romantic eras. His compositions include nine symphonies, five piano concertos, his great mass, the 'Missa Solemnis', and his only opera, 'Fidelio'. **356 dots**

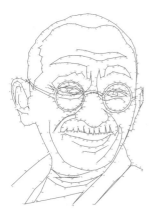

Page 24

Mahatma Gandhi, 1869–1948

Mohandas Karamchand Gandhi, more commonly known as Mahatma (meaning 'Great Soul') used non-violent civil disobedience in India to eventually gain independence from Britain. Gandhi trained as a lawyer before becoming an activist, which cost him several spells in prison. Acclaimed for fathering the Indian nation in August 1947, he was assassinated at point blank range by the Hindu nationalist Nathuram Godse less than six months later. **474 dots**

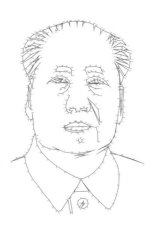

Page 25

Mao Zedong, 1893–1976

Commonly referred to as Chairman Mao, Zedong is seen as the founding father of the People's Republic of China and governed the country as Chairman of the Communist Party from 1949 until his death. Mao is credited for modernizing China and building it into a world power. A compilation of his writings, 'Quotations from Chairman Mao', known as the 'Little Red Book' were made available to everyone in China. **400 dots**

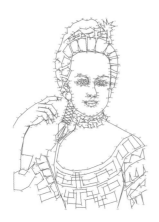

Page 26

Margaret Thatcher, 1925–2013

Thatcher became the first (and only) female British Prime Minister in 1979 and won two more elections until resigning as Conservative party leader in 1990. Despite her strong popularity in some quarters, which peaked around the 1982 Falklands War, she was a controversial figure to the end. Some see her as saving Britain from economic decline, whereas others believed she destroyed the rights of millions of workers. **462 dots**

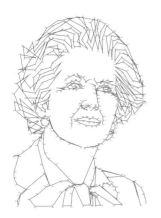

Page 27

Marie Antoinette, 1755–1793

Married at 15 years of age to the future French king Louis XVI, Marie Antoinette's extravagant lifestyle at the Palace of Versailles helped provoke the popular unrest which led to the French Revolution and abolition of the monarchy in 1792. The king was arrested in 1793 and then Marie Antoinette was arrested and tried on falsified crimes against the French republic. She was sent to the guillotine aged 37. **604 dots**

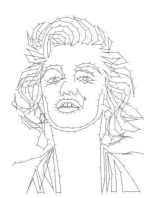

Page 28

Marilyn Monroe, 1926–1962

Monroe became one of the most famous sex symbols of the 1950s for her roles in popular Hollywood comedies. After a difficult childhood and a first marriage aged 16, Monroe began a successful modelling career before moving to acting. She won an Oscar for her role in 'Some Like It Hot' (1959), but struggled with depression and two high-profile divorces, and committed suicide aged 36. **425 dots**

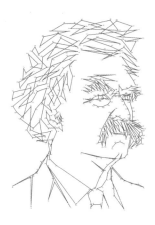

Page 29

Mark Twain, 1835–1910

Born Samuel Langhorne Clemens, writing under the pen name of Mark Twain, the American author and humorist grew up in Missouri, which provided the setting for 'The Adventures of Tom Sawyer' (1876) and its sequel 'Adventures of Huckleberry Finn' (1884). His wit and satire earned praise from critics and peers and he was lauded as the 'father of American literature' by the writer William Faulkner. **400 dots**

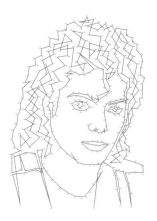

Page 30

Michael Jackson, 1958–2009

The 'King of Pop' enjoyed a hugely successful career as a child member of the Jackson 5 and as a solo artist. He was particularly popular in the 1980s for his albums 'Thriller' (1982) and 'Bad' (1987), as well as for his 'moonwalk' dance routine. After announcing a grand-scale comeback tour starting in London, he died of a drug overdose just three weeks before the first show. **390 dots**

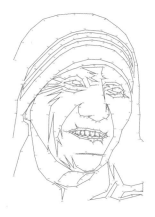

Page 31

Mother Teresa, 1910–1997

Mother Teresa was the founder of the Order of the Missionaries of Charity, a Roman Catholic religious congregation dedicated to helping the poor. She was born in Macedonia, before moving to Ireland and then India, where she spent most of her life. She was lauded for her charity work and won the Nobel Peace Prize in 1979, but was also criticised for opposing contraception. **351 dots**

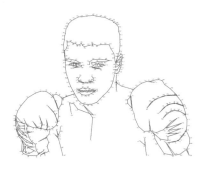

Page 32

Muhammed Ali, 1942–

Born Cassius Marcellus Clay, Ali is considered one of the greatest athletes of all time for his dominance of heavyweight boxing in the 1960s and 1970s. As well as being involved in several historic boxing matches, he is known for his public stance against the Vietnam War, refusing to fight in 1967. He later converted to Islam and has been suffering from Parkinson's syndrome since 1984. **387 dots**

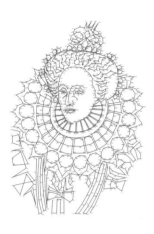

Page 33

Queen Elizabeth I, 1533–1603

Also known as the Virgin Queen, Elizabeth I ruled England and Ireland for 44 years from 1558 without ever marrying or producing an heir. The last monarch of the Tudor dynasty, her rule is considered to be a Golden Age for its stability and prosperity, as well as the defeat of the Spanish Armada in 1588. Elizabeth was succeeded by James I, son of her cousin Mary, Queen of Scots. **943 dots**

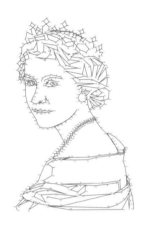

Page 34

Queen Elizabeth II, 1926-

Elizabeth II became the longest ever reigning monarch in 2015, her 63 years on the throne overtaking Queen Victoria. She is officially Queen of the United Kingdom, Canada, Australia and New Zealand, as well as Head of the Commonwealth. She has had four children with her husband Philip – Charles, Anne, Andrew and Edward. **498 dots**

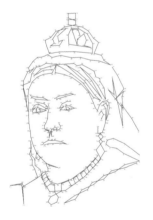

Page 35

Queen Victoria, 1819–1901

Victoria inherited the throne aged 18 in 1837 and went on to rule the UK and Ireland, and the expanding British Empire, for the rest of the century. She had nine children with her husband Prince Albert, but fell into a great mourning when he died prematurely in 1861. Her reign saw great expansions in industry and science, including the building of railways and the London Underground. **342 dots**

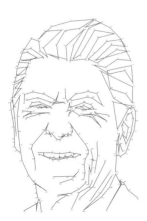

Page 36

Ronald Reagan, 1911–2004

Reagan was the 40th President of the United States from 1981 to 1989. He had previously served as Governor of California and President of the Screen Actors Guild. He became well-known for his economic policy 'Reaganomics' and his pressure on the Soviet Union to end the Cold War and tear down the Berlin Wall. His continued approval amongst public opinion marked a shift towards conservatism in the USA. **313 dots**

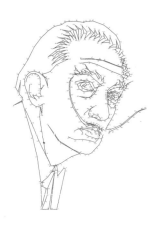

Page 37

Salvador Dali, 1904–1989

Salvador Domingo Felipe Jacinto Dali was a Spanish artist born in Catalonia. He practised Surrealism after spending time with Picasso, Miró and Magritte in Paris in the 1920s. He is best known for his painting 'The Persistence of Memory' (1931), commonly referred to as 'The Melting Watches'. Dali was as famous for his eccentric public persona (and flamboyant moustache) as for his art. **443 dots**

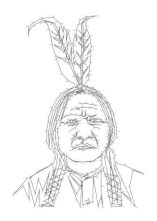

Page 38

Sitting Bull, 1831–1890

Sitting Bull was a Hunkpapa Lakota holy man and tribal chief who united the Sioux tribes in their struggle for survival against the US government. He inspired his people to a major victory at the Battle of the Little Bighorn, before performing in Buffalo Bill's Wild West Show. He was shot dead by agency police on the Standing Rock Indian Reservation amongst fears he would support the Ghost Dance movement. **475 dots**

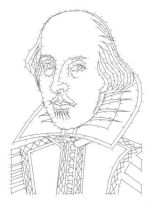

Page 39

William Shakespeare, 1564–1616

'The Bard' is largely considered the greatest writer in the history of English literature. He was born in Stratford-upon-Avon and moved to London to act and write for the Lord Chamberlain's Men. Shakespeare wrote over 150 poems, but is most well known for his plays, including 'Hamlet', 'Macbeth', and 'Romeo and Juliet'. He is also credited with inventing over 1,700 words. **536 dots**

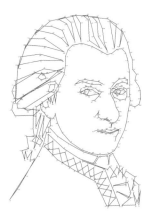

Page 40

Wolfgang Amadeus Mozart, 1756–1791

Mozart was an Austrian composer in the Classical era, producing more than 600 works. He was a child prodigy on the keyboard and violin, and by the age of five he was already composing and performing before European royalty. He achieved fame in Vienna while creating his best-known symphonies, concertos and operas, but died of an undefined illness at the age of 35. The composer Joseph Haydn said of him that "posterity will not see such a talent again in 100 years." **357 dots**

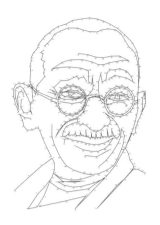

This edition published by Southwater, an imprint of Anness Publishing Ltd,
108 Great Russell Street, London WC1B 3NA
info@anness.com; www.annesspublishing.com
twitter@Anness_Books

© Anness Publishing Ltd 2016

Publisher: Joanna Lorenz
Editorial Director: Helen Sudell
Editorial Assistant: Matt Bugler
Illustrations by Glyn Bridgewater

Publisher's Note
Although at the information in this book is believed to be accurate and true at the time of
going to press neither the author nor the publisher can accept any legal responsibility or
liability for any errors or omissions that may have been made.